Seeing Picasso, Fixing Cézanne

Peter V. Moak

Order this book online at www.trafford.com
or email orders@trafford.com

Most Trafford titles are also available at major online book retailers.

Print information available on the last page.

ISBN: 978-1-4907-8661-2 (sc)
ISBN: 978-1-4907-8662-9 (e)

Library of Congress Control Number: 2018900079

Trafford rev. 01/31/2018

Trafford
PUBLISHING® www.trafford.com

North America & international
toll-free: 1 888 232 4444 (USA & Canada)
fax: 812 355 4082

Seeing Picasso, "Fixing" Cézanne

The Visual Ego and the Visual World

The works of Pablo Picasso and Paul Cézanne are based on particular ways of seeing.[1] To understand these we begin with ordinary vision.

I open my eyes and light streams through the lenses and forms pictures on my retinas. From these tiny pictures my brain places before me a life sized, lens projected, stable, upright, continuous picture of objects in space, the *visual world*. I recognize this world as the real world even though I know it is an event in my brain, a virtual reality. But how do those tiny pictures come to be the world around me? Part of my answer would be an imagined scaled to the visual world presence I have in relation to which I see the visual world. I call this regularized imagined image of my face my *visual ego*.[2] I see the visual world in relation to my visual ego in two basic ways. With the first the world is like a picture that sits before and apart from me. However, if I physically move even just my eyes the relationship between my ego and the things in the visual world changes. I become aware of my visual ego and I find myself in the visual world. I call the second way the *aligned way*. For an aligned view I stop before an object and imagine a point behind my ego aligned with an edge of my ego. When I do so this edge becomes either an ideal vertical or horizontal line in relationship to which I see this object and then other objects. If I maintain the relationship between the edge of my ego and the edge of an object other edges in the visual world are sequentially seen in relationship to the initial object edge. These edges and so objects seen in relation to the straight ego outline are seen evened out, regularized and the visual world as an idealized, coherent, lens projected, geometric structure that is both comprehensible and memorable. Using my imagination I can move in and out of the idealized visual world by changing the

size of my aligned visual ego. When my aligned ego is made larger than an object I look inward across space to an edge of the object. When the aligned ego is made smaller than an object the contours of the object spread out from my ego and I seem in the same space and closer to the object. This can make a distant object appear life sized a phenomena called constancy scaling. When I move from object to object my relationship remains continuous if I first peripherally relate the next object to the fixed edge of the first. If on the other hand I first move my eyes to a next object this object is seen related to the not aligned ego and so *disconnected*. Thus I can see the visual world as unaligned and remote unless I move or in relation to my static aligned visual ego as a coherent geometric lens projected structure. All this provides me with the visual grammar I use to guide my progress in the world.

This description of how I see the world may seem quite complex. It does to me, but I think it is what we all do all the time and something we all can be aware of. The static aligned ego way of seeing the world may seem similar to how we make a work of art and my experience is that it is just so. A *work of art* is by my definition a thing made by a human being using the visual ego in a particular way which I call the *perspective*. My experience that a work of art being based on a static aligned ego is a world in itself, an alternative reality. Becoming aware of the visual ego and the different ways it makes the world look becomes all important when it comes to art. To properly see a work of art one needs to see it as it was seen when it was made by using the proper perspective. Finding the right perspective is by trial and error. When I find the right perspective a work of art looks its *aesthetic best*, aesthetic best being a universal resulting from a coherent relationship between parts and not a matter of *taste*, taste being a social or individual preference.

Perspectives
(the names are mine)

—————

Frontal or Semitic Perspective.
With frontal perspective the static aligned ego is made smaller than an object so that edges spread out from us and we occupy the same space as the object. If we first relate the next object to the fixed edge of the first object edge when we moves from object to object forms are seen continuously related. I find frontal perspective to have a long history beginning with the art of Semitic speaking peoples and might well be called Semitic perspective. It becomes the dominant perspective in Europe beginning in the late middle ages and remains so in the west do this day.

Oriental Perspective.
With what I call Oriental perspective the static aligned ego is made larger than an object which is seen across space and we look in at an edge of the object. It is relative to this edge other objects are seen. Oriental perspective is a characteristic of works of art from the Far East including China, Southeast Asia, Central and North East Asia, Korea and Japan. Oriental perspective is also found in the art of indigenous North Americans and that of Central and South America.

Peripheral Perspective.
With frontal and Oriental perspective we place ourself before an object. It is also possible to see objects from the side. This is done by placing the ego to the side of an object so that it is seen at an oblique angle and the composition as a sequence of separate obliquely seen parts. Peripheral perspective is a characteristic of the early art of the Indo-European speaking peoples and post modern architecture.

Attic Perspective.

Toward the middle of the fifth century BC artists in Athens refined frontal perspective by relating a point beyond an object to a small reduced to a point. The contours of the object spread out from this focal point like ego.

Hellenic Perspective.

In the mid fourth century BC a perspective appears in Greece based on an ego larger than the frontal perspective ego which produces an almost perpendicular relationship to objects' This produces a wider view but a less exact definition three-dimensional form. Hellenic perspective is used in late fourth century Greek art and variously during the Hellenistic period.

African Perspective.

With frontal, Oriental and peripheral perspective objects are seen in relation to the static aligned ego. What I call African perspective depends on a small static aligned ego placed next to forms that are then seen related to the not aligned ego. This produces a composition of disconnected forms related to the not aligned ego that confront us in turn. African perspective is a characteristic of early works of art coming from a "path" stretching from sub-Saharan Africa into India.

Oceanic Perspective.

Oceanic perspective forms like those of African perspective are seen in relation to the not aligned ego. With Oceanic perspective a large static aligned ego is placed next to a form that is then seen in relation to the not aligned ego. Again the disconnected forms confront us in turn. Oceanic perspective is a characteristic of early art coming from South East Asia, Australia and Oceania.

European Perspective.

Some of the oldest surviving representational works of art are those of stone age Europe, Old Europe. These are based on divisions between parts seen related to the not aligned ego with parts then seen in relation to the small static aligned ego. Such divisions appear relatively two-dimensional and so divide the composition. Unaligned divisions are also found in Etruscan art, Roman art and in the twentieth century in the work of Georges Braque and some other Cubists.

Cézanne Perspective

Cézanne's perspective, Cézanne's way of seeing and composing his work begins with a static aligned large ego wide view. In this context a individual shape is seen related to a static aligned large ego. An adjacent shape is seen across from the first

shape and related to the not aligned ego. This shape is finally seen in relation to the static aligned large ego and so forth. In this way Cézanne isolates and individualizes shapes in a composition held together by the context of a wide view. In addition Cézanne forms are seen in a surrounding space and diminished in scale. A Cézanne composition is a sequence of disconnected highly inventive shapes bound together by an overall view. Around 1885 Cézanne begins fixing the position of his ego.

Picasso Perspective.

In the spring of 1907 Picasso relates his static aligned large ego to a point in the center of a shape That greatly reduces size of his ego to almost a point. He places this ego very close to the surface of the shape so that the edges of the shape are very obliquely seen. An adjacent shape is seen related to the not aligned ego and disconnected and then the point like ego is related to a point on the next shape and so on. With Variation Two, also summer 1907, a now initially small ego is used in the manner of Variation One. Variation Three, spring 1908, relates a point now beyond a shape to the static aligned small point like ego with an adjacent shape seen related to the not aligned ego and then to the aligned ego and so on. Variation Four, fall 1909, a point beyond a shape is related to a static aligned now initially large point like ego with succeeding shapes again first seen related to the not aligned ego and then the aligned ego. Variation Five relates points behind shapes and a now fixed small point like aligned static ego. With Six, fall 1910, the large point like fixed aligned static ego is used as with Five. Variation Seven, spring 1912, an initially small point like fixed aligned static ego is related to a point now on the surface of a shape. A next shape is seen in relation to the not aligned ego and then the aligned ego and so on. Eight, fall 1912, an initially now large point like ego aligned fixed ego us used in the same manner as Seven. From here on Picasso will use Seven or Eight for a period of time and then switch to the other. I see Picasso perspective as an anamorphic perspective unique to Picasso.

Variations in Perspective.

The following are variations found in the above perspectives. These include a *wide view* using Oriental or Hellenic perspective. A wide view can create large scale coherence. When the ego does not move in relation to a composition I call it the *fixed ego*. This can enhance coherence. The conceiving of *space around objects* is a characteristic of French, Spanish and Italian art. Objects seen in relation to the aligned static ego can be seen *reduced in scale*. Reduced scale is a characteristic of Spanish and Italian art. *Disconnection* which breaks up a composition occurs if the eyes moves to a next object without the shape first being peripherally related to the static edge of the first object.

Seeing Picasso

———————

Pablo Picasso, 1887-1971, is famous for the variety and inventiveness of his art which has been explained by his biography, art influences, philosophy, politics, history and culture, but not by Picasso's ways of seeing, by his perspectives.[3] I find Picasso using eleven different perspectives from his youth to the fall of 1912. He never explained these so to understand them we must turn to his works themselves.

Picasso's First Perspective.
Palo Ruiz Picasso was born in Malaga, Spain on October 25th, 1881. His father, Jose Ruiz Blasco was a drawing teacher and painter whose use of wide-view Hellenic perspective gives his works a coherence not found in that of his son. In 1891 Picasso's family moved to La Coruna, Spain and in 1895 to Barcelona were Picasso enters art school. In October 1900 Picasso makes his first trip to Paris to see the Universal Exposition at which he has a painting, *Science and Charity*, 1900, Picasso Museum, Barcelona and to learn about the Paris art world.[4] The painting which is based on the not aligned ego is pleasing in detail, the head of the doctor, a portrait of his father, the child, but is not coherent.[5] While in Paris Picasso makes a painting of a Parisian dance hall, *Le Moulin de la Galette*, 1900, Guggenheim Museum, New York City, using his initial perspective.[6] Compare it to Toulouse Lautrec's *At the Moulin Rouge, 1892,The Art Institute of Chicago*, a similar subject which is a unified, wide view, frontal perspective composition filled with the curvilinear shapes and harmonious colors of Art Nouveau. The Picasso has some closed shapes and curvilinear outlines while other shapes are angular and discordant. This dissonance was perhaps even more disturbing at the time than the lesbians in the foreground. However it is this dissonance that energizes the nocturnal scene and sets it apart. Picassos impediment is here a strength. Picasso came to Paris to catch up. When he Leaves that same year he is in a way already moving ahead.

Picasso's Second Perspective.

In the fall of 1901 on a second trip to Paris Picasso discovers peripheral perspective which is his firsts use of the static aligned ego. It would seem that this change was inspired by the woodcuts of the French painter Paul Gauguin then in Tahiti that belonged to a mutual friend the Basque sculptor and ceramist Paco Durio.[7] Seen in a Picasso drawing, *Parisian and Exotic Figures*, 1901, Picasso Museum, Paris, are images based on peripheral perspective, forms in space that suggest such Gauguin woodcuts as *Te Atua*, 1892, Art Institute Chicago, which is based on a wide-view peripheral perspective. Paul Gauguin discovered peripheral perspective at the 1889 Paris Worlds Fair.[8] Because he discovered peripheral perspective in art from India and Indonesia he may have thought it not western. Ironically it is a characteristic of the early art of the Indo-European speaking peoples. Gauguin's *Portrait of a Woman with a Still Life By Cézanne*, 1890, Art Institute of Chicago, indicates that his was a conscious change.[9] The woman in the chair is based on peripheral perspective while the Cézanne still life on the wall is based on Gauguin's original frontal perspective. The real Cézanne which Gauguin owned is based on Cézanne perspective, a wide view in the context of which the large ego is aligned to individual forms that are first seen in relation to the not aligned ego and so disconnected. At times Gauguin switches his perspectives back and forth. This is similar to Picasso's later practice of alternating perspectives. Gauguin deserves credit for inspiring the first important turning point in Picasso's perspective career. Picasso like Gauguin documents his change in perspective with a painting, the *Blue Room*, 1901, Philips Collection, Washington D.C.[10] The area above the bed including a Lautrec poster is based a not aligned ego while the bathing girl and her surroundings are based on peripheral perspective. With his blue period Barcelona painting *The Blind Man's Meal*, 1903, Metropolitan Museum of Art, New York City, Picasso gives us a reason for the use of peripheral perspective. Seen here is a blind street singer seated at a table holding a piece of bread and touching an earthenware jug. As the obliquely presented forms sequentially materialize they seem touchable giving blindness and poverty a seeming physical presence.[11] The illusion of a tactile presence will continue as a major concern of Picasso's. Picasso uses peripheral perspective for five years, his so called Blue and Rose periods.

Picasso's Third Perspective.

In the fall of 1906 after a summer in Spain Picasso adopts a perspective based on Oriental perspective. This Third Perspective the static aligned large ego is related to shapes not reduced in scale first seen in relation to the not aligned ego and disconnected. Disconnection allows for startling inconsistencies between parts. A work that marks this change is *Peasants and Oxen*, fall 1906, Barnes Foundation,

Philadelphia.[12] Picasso's *Two Nudes*, 1906, Museum of Modern Art, New York City, presents two full length, hulking female nudes that face each other before a brown curtain.[13] There is the suggestion of a mirror images, but they are strangely different. Even stranger is the relationship between their parts. Disconnection permits the radical differences in scale, color and view. For example the head of the figure on our left is larger in scale than her torso while her hand and arm are larger still. Picasso gives these images a presence, a new "reality", by their changing in character relative to each other as we move around them. The radically disconnected shapes are a major step toward what will be called Picasso's cubism. This change in perspective may have been motivated by two portraits in the collection of Leo and Gertrude Stein. These are Cézanne's *Portrait of the Artists Wife*, before 1885, Foundation Brülrle, Zurich and Matisse's *Woman with a Hat*, 1905, San Francisco Museum of Art.[14] The Cézanne is based on Cézanne perspective and the Matisse on a perspective Matisse adopts in 1905, the composition as a whole is seen in relation to the fixed large static alged ego, a wide view and then in this context shapes individually and finally seen related to the not aligned ego.[15] It would seem that the radical nature of these portraits was apparent to Picasso, but maybe not the methods. In the spring of 1906 using peripheral perspective Picasso began painting his *Portrait of Gertrude Stein, 1906*, Metropolitan Museum of Art, New York City.[15] After many sittings he leaves this unfinished only to take it up again in the fall of 1906 when he repaints only the face using his third Perspective. This disconnects face and figure in a way that anticipates systematic incongruities to come. Salient here for me is what I see as Picasso's growing awareness that discontinuity could be the basis of a radically new kind of picture.

Picasso Perspective Variation One.
In late 1906 and early 1907 Picasso began making studies for a large painting, the future *Les Demoiselles d'Avignon*, 1907-8, Museum of Modern Art, New York City. When one arranges the drawings in accordance with the number of figures, the poses and the perspective at a point a strange female figure with a triangular torso and arms that form a rectangle around her head appears which is similar to mourning figures found on Attic geometric vases.[16] At first this figure is based on Picasso's third perspective. But a large drawing of this figure, *Figure Seen From the Back*, 1907, Picasso Museum, Paris, has its outlines changed except for those of the head so that it is now based on a new perspective, Picasso Perspective Variation One.[17] For this new perspective Picasso aligns a point behind his initially large ego to the edge of his ego which he relates to a point on the surface of a shape reducing the size of his ego to a point. He brings his point like ego close to the surface of this shape the edges of which are very obliquely seen. A following shape

— 9 —

is seen relative to the not aligned ego and so disconnected. When the point like ego moves to this shape and the edges of this shape become related to the point like static aligned ego and so on. As a result images are seen as an assemblage of cut out, disconnected, flattened, startlingly immediate shapes. An inspiration for this new perceptive may have been the work of Cézanne and Matisse, but I think a more likely source is the Protogeometric Greek vase painting where I think Picasso found the figure with rectangular arms. However these vase painting are based on African perspective where a small ego is placed next to a shape that is then seen in relation to the not aligned ego. Having found his new perspective Picasso proceeds to paint *Les Demoiselles d'Avignon*. Because he later repaints the right and left sides of the picture with a second and third variation on his new perspective it is today a three part picture. Only the central part including a standing and a seated figure and a gray background curtain are based on Variation One. To see this part of the picture relate a point on a shape and the static aligned point like initiallylarge ego and place this ego close to the surface of the shape so that the outlines of the shape are veryobliquely seen. See a next shape relative to the not an not aligned ego so that it is disconnected and then move and relate your point like ego to the next shape. Continue in this way and you find yourself confronted by an succession of flattened, cut out shapes that constitute the two central very unconventional "Demoiselles".

Variation Two

I find tition with adjacent forms seen related to the not aligned ego.[18] A drawing in this catalogue of a frontal female nude with hands clasped below her waist along with a painting, *Woman with Joined Hands*, 1907, Picasso Museum, Paris are based on Variation Two. The pose and form of this figure suggest a *Female New Caledonian Roof Finial*, Picasso Museum Paris, that Picasso owned.[19] The water color, *Five Nudes*, 1907, Philadelphia Museum of Art which is based on Variation Two shows that Picasso considered repainting the entire *Les Demoiselles d'Avignon* using this perspective.[20] Around this time Picasso visits the Trocodéro Museum and is struck by the power of African and Oceanic art to "mediate with the world of the spirits."[21] He also may have seen African and Oceanic shapes as similar to those in his own new work and that his new perspective gave him similar powers. The influence of African and Oceanic art is clearly seen in the pronounced shapes, striping, strong colors and disparate scaling of the heads of the two figures on the right whose mask like faces seem cut from pieces of wood. Today only the right side of the painting, the standing and the squatting figure, the blue curtain and the still life on a table are based on Variation Two.

Variation Three

In early 1908 Picasso introduces Variation Three.[22] The static aligned initially small point like ego is now related to a point behind a shape, (Attic perspective) and placed close to the surface of the shape the edges of which are very obliquely seen. A next shape is seen related to the not aligned ego and disconnected and then seen in relation to the aligned ego and so on. Variation Three surfaces are less immediate than those of Variation two. At this terspective, Variation Two, using a now initially small static aligned point like ego that is related to a point on the surface a shape and brought close to the surface of the shape causing contours to be very obliquely seen. The next shape is seen relative to a not aligned ego and disconnected and then to the aligned ego and so on. The result is a sequence of even more immediate shapes. Some drawings in an April 1907 catalogue of a Daumier exhibition based on Variation Two show that Oceanic art may have inspired Variation Two even though Oceanic perspective is based on a large ego oriented to points in a compos

ime Picasso completes *Les Demoiselles d'Avignon* using Variation Three by repainting the figure on the left who strides onto the scene while brushing back a brown curtain.

Les Demoiselles d'Avignon was and is a wildly unconventional work that eclipsed Post Impressionism, Fauvism and Matisse. At the same time *Les Demoiselles d'Avignon* is not the chaotic work so often described, but a carefully constructed tripartite composition that records three variations on Picasso's new perspective. These strange, statuesque women who have the face of Fernand Olivier, Picasso's mistress, appear to me neither monsters nor erotic and not necessarily prostitutes. For me with their peculiar blend of the Classical and African traditions they celebrate of a sort of a heroic womanhood the seeming subject of numerous Picassos of this time and to come.

Picasso Perspective Variation Four.

During the summer of 1908 while working north of Paris at La Rue des Bois Picasso again varies his new perspective. With Variation Four a point beyond a shape is related to a now initially large static aligned point like ego placed close to the surface of a shape the edges of which are very obliquely seen. A next surface is seen related to the not aligned ego and disconnected. The point like ego is then aligned to a point behind this next shape and so on. At this time geometric abstraction increases, but all shapes remain representational. See *Landscape, La Rue des Bois*, 1906, Museum of Modern Art, New York City.[23] Picasso will use Variation Four until the fall of 1909. In the fall of 1908 he completes the large three figure composition, *Three Women*, 1907-8, Hermitage Museum, St. Petersburg, which begins as a Variation Two work, is repainted using Variation Three and

finally repainted again using Variation Four.[24] Seen here are three robust women who despite their heft are entirely feminine.[25] My experience is one of moving before a monumental relief in contrast to the more planar *Les Demoiselles d'Avignon*. In early 1908 while working on *Three Women* Picasso is visited by Georges Braque. Braque's original perspective is similar to Oriental perspective but using a narrower ego. Sometime after meeting Picasso and seeing *Three Women* Braque begins placing divisions not related to the not alined ego between his shapes (something found in the art of stone age Europe). See Braque's *Large Nude*, 1908, Private Collection.[26] In the fall of 1908 Braque begins exhibiting "Picasso-like" works which come to be called Cubism. Soon two other French artists, Fernand Léger and Robert Delauney and a little later the Catalan, Juan Gris begin using these divisions. From here Cubism spreads around the world.[27] Picasso spends the summer of 1909 at Horta de San Juan, Spain where he paints Variation Four works including *Reservoir*, 1909, Private Collection, a view across an animal watering pool to houses on a hill top where the viewer jumps goat like from house to house.[28] Notice how the right side of the pool and the facade of a house beside it have been enlarged and displaced some 180 degrees, a radical incongruity that anticipates Picasso to come.

Variation Five.
In the fall of 1909 Picasso returns to Paris where he introduces Variation Five. A now fixed in relation to the composition static aligned initially small ego is related to a point beyond a shape, so reduced to a point like ego placed close to the surface of a shape placed close to the surface of the shape the edges of which are very obliquely seen. A next shape is first seen related to the not aligned ego and then related to a point behind this next shape and so on. The major difference here is that the ego does not move in relation to the composition. Instead shapes themselves seem to move when they change from being related to the not aligned ego to the fixed aligned central ego.

I find these kinetic images to be new to the history of art. See *Still Life with a Liqueur Bottle*, 1909. Museum of Modern Art, New York City painted at Horta Spain using Variation Four and repainted in Paris, fall 1909 using Variation Five.[29] The composition centers on a ceramic rooster, a vessel for drinking wine around which beginning in the upper right are a distant mountain, a folded newspaper, a glass, a liqueur bottle lying on its side and another bottle standing in the lower left. Behind the table are the folds of a green curtain. During the winter of 1909-10 Picasso's pictures become more and more puzzles to be solved. The Variation Five, *Girl with a Mandolin*, 1909-10, Museum of Modern Art, New York City, shows a

half-length female nude posed before stacked canvases in the artist's studio.[30] The rounded contours of her easily recognizable breasts and those of the mandolin stand in contrast to the rectangular shapes that make up her face. Degree of legibility is up to Picasso.

Variation Six.

In the fall of 1910 Picasso repaints several paintings from a summer at Cadaques Spain using Variation Six. Six differs from Five in being based on a sort of Attic Oriental perspective rather than on an Attic perspective. Six begins with a now initially large static aligned fixed ego related to a point beyond a shape, so reduced to a point and placed close to the surface of the shape the edges of which are very obliquely seen. The next shape is first seen related to the not aligned ego and disconnected and then related to a point on this next shape and so reduced to a point like ego placed close to the surface of a shape placed close to the surface of this shape the edges of which are very obliquely seen and so on. Again there is an apparent change of position when a shape shifts from being related to the not aligned to the aligned ego. See *Guitarist*, summer 1910, repainted fall 1910, National Museum of Modern Art, Paris.[31] Follow the shapes as they are not related and then related to the point like central fixed aligned ego and a half length figure of a singing man holding a mandolin emerges (guitar is a misnomer). His left arm supports the neck of the instrument while his right hand supports its base. Notice how darks along edges cut out shapes. Only slightly less enigmatic is the precisely painted *Portrait of Daniel Henry Kahnweiler*, winter of 1910-11, The Art Institute of Chicago.[32] Picasso has framed this Variation Six, half length seated portrait of his dealer with a collection of African and Oceanic works of art. In addition to describing such works as magical Picasso called them rational.[33] Kahnweiler's mask like face spread across rectangular facets may be an amusing reference to the reason Kahnweiler sought in Picasso's cubism. Another Variation Six work that is almost a pendant to the *Kahnweiler Portrait* is *Portrait of a Woman*, 1910, Museum of Fine Arts, Boston which seems to embody the magical side of African and Oceanic art.[34] Follow the bouncing facets and you find a half length female nude who with her left hand holds an "African" mask above a face shrouded in shadow. Around her float a group of African and Oceanic works of art. Their flickering presence is reminiscent of the Gauguin woodcuts that first put Picasso on the road to cubism. Picasso spent the summer of 1911 at Céret in the South of France. He uses Variation Six to paint a number of figure compositions, still lives and a Landscape in which are imbedded Picasso and his pet monkey. See *Landscape by Céret*, 1911, Guggenheim Museum, New York City.[35] From the following winter comes *Ma Jolie, Woman with a Zither*, 1911, Museum of Modern Art, New York City. This Variation Six study

of a half length seated nude woman holding a zither turns out to include portraits of Eva Gouel and Picasso himself. Begin with a initially large fixed central static aligned ego that is reduced to a point by being related to a point beyond a shape that is placed close to the surface of this shape the edges of which are very obliquely seen. See the next shape as not aligned and then aligned and so on. Seeing the composition step by step in this way reveals Eva holding a zither in the crook of her right arm while her left hand rests on the strings of the Zither. Surrounding her beginning in the upper right are a curtain, a bit of decorative cord, a large tassel, an arm of her chair, a sheet of music with the words "Ma Jolie" (the name of a popular song), the other arm of the chair, a glass on a table, the head of a cat and what may look like still life but is actually the very geometric face of Picasso, pipe in mouth, perhaps caught in a mirror.[36]

Variation Seven.
Sometime in the spring of 1912 Picasso adopts a Seventh Variation on Picasso perspective. Begin by relating an initially small fixed central ego related to a point now on the surface of a central shape rather than behind the shape which again reduces the ego to a point. This ego is placed very close to the surface of this shape the edges of which are very obliquely seen. See an adjacent shape related to the not aligned ego and disconnected. A point on this shape is then related to the central fixed point like ego and so on. Again surfaces seem to shift when they change from being seen not aligned to aligned. At this time Picasso begins adding unusual materials to pictures such as *Still Life with Chair Caning*, 1912, Picasso Museum, Paris. These additions seem a natural adjunct to works composed of seemingly cut out shapes.[37] Seen here are a newspaper, pipe, glass, knife, slice of lemon and scollop shell on a table next to a caned chair seat. To the painting Picasso has added a piece of oil cloth printed to look like chair caning and a piece of rope as a frame. The trick, the illusion, here is that in this Variation Seven context these additions look as painted as everything else.

Variation Eight.
In the fall of 1912 after a summer at Corot and Ingres Picasso modifies some of his summer 1912 paintings with a final variation on his new perspective, Variation Eight. This is based on static now initially large static aligned fixed central ego which is related to a point again on the surface of a central shape so that it is reduced to a point that is placed close to the surface of the shape the edges of which are very obliquely seen. An adjacent shape is then seen disconnected by being related to the not aligned ego and then related to the aligned ego and so on. Again this shape seems to move when it changes from being related to the not aligned

ego to aligned ego. *Man with a Guitar*, 1912, Philadelphia Museum of Art is one of the summer 1912 Variation Seven paintings Picasso repaints in the fall of 1912 using Variation Eight.[38] Shown here is a man dressed as a bullfighter holding a guitar and seated at a table on which rests a conical confection of some sort. That fall Picasso begins making pasted paper compositions using Variation Eight. These line drawings that in some cases include painted shapes and pieces of newspaper, ephemera made permanent. With *Man with a Hat*, 1912, Museum of Modern Art, New York City, a self portrait, the piece of newspaper sets off a shape and suggests shadow.[39] An interesting parallel exists between printed matter and Picasso perspective. Both must be read or seen, strictly in sequence That fall Picasso makes a cardboard sculpture, *Guitar*, 1912, Museum of Modern Art, New York. Picasso says the idea for representing the sound hole of the guitar as a cylinder which places it on a different plane came from a *Greco Mask* which he owned, Picasso Museum, Paris,. Nevertheless the effect of the *Mask* and the Guitar is quite different. The not aligned forms of the mask mysteriously materialize one at time in a manner consistent with its religious nature. I see the parts of the Guitar, an everyday object materializing and then fading away as if in a dream or memory, a past recaptured.[40] Picasso's sculpture of this time and beyond reside in the same illusionary space as the paintings and drawings being based on the same basic perspectives.

And Beyond

Picasso continues to use Eight until the spring of 1914 when he returns to Seven, see *Pipe Glass and Bottle of Rum*, Museum of Modern Art, New York City.[41] Picasso's practice is to use Seven or Eight for a period of time and then switch to the other. In December 1915 Picasso writes Gertrude Stein about visits to a clinic where Eva is dying and about a recent work, *Harlequin*, 1915, Museum of Modern Art, New York City.[42] This Variation Eight *Harlequin* pictures Harlequin the trickster, Picasso's sometime alter ego, leaning on a table holding a portrait of Picasso.[43] Concealed in the scumbling that picks out Picasso's profile is the barely discernible, emaciated face of Eva.[44] Much has been made of the relationship between Picasso's life and art and rightfully so as Picasso's private life is often in his work. However it does not follow that knowing about his life tells us how to look at his work which one must know if one is to properly connect his life and work. His Variation Eight, *Nude Woman,"Jaime Eva"*, 1912, Columbus Museum of Art, Ohio, depicts a standing, largely nude Eva holding a card saying "Jaime Eva."[45] Draped around her I see the previously not identified Picasso whose hands frame her breasts. What seems a less affectionate view of Eva is found in Picasso's Variation Eight collage *Au Bon Marché*, 1912-13, Ludwig Collection, Aachen, Germany. Here a box top from a Paris department store, an advertisement from another Paris

store which refers to feminine apparel and some wall paper make up a cash register toward which a hand gestures. Picasso's? On the right in the guise of a glass are the head and shoulders of a woman whose downcast eyes suggest shame while on the left a bottle appears to me be the head of Picasso's faithful dog Frika?[46] Another "still life" where Picasso's private life is present in disguise is the Variation Seven *Still Life with a Pedestal Table*, 1931, Picasso Museum, Paris. Posing as a compote and a table is the dancing Marie-Térese Walter, Picasso's young mistress who lifts her skirts to her waste. On her right is a huge head with rolling eye. Stranger still, caught in the handle of a yellow pitcher is a head wearing a crown like that worn by Herrod in Picasso's 1905 dry point, *Salomé*. It would seem that Marie-Térese is Salomé and the head of St. John the Baptist, Picasso.[47] In 1948 we find Picasso again playing games under the cover of his peculiar perspective with two paintings called *The Kitchen*, 1948, Picasso Museum, Paris and Museum of Modern Art, New York City. Françoise Gilot, Picasso's companion and mother of two of his children writes that under Picasso's direction she began the second, the New York, by producing a minimal version of the first which Picasso had complicated with "real details," plates, bird cadges and a potted plant. Both these Variation Seven compositions turn out to contain two large heads, Picasso's on the right and on the left Françoise kissing Picasso on the cheek. Behind Françoise is baby Claude.[48]

Picasso uses Variation Eight following Seven for a little over a year, fall 1915 to early 1917, when, in Rome he returns to Variation Seven. He continues to use Seven until the summer of 1921 when at Fontainebleau he paints to two large cubist canvases called *The Three Musicians*. The first is based on Variation Seven, Museum of Modern Art, New York City and the second on Eight, the Philadelphia Museum of Art. A third, large, non-cubist painting from Fontainebleau, *Three Women*, 1921, Museum of Modern Art, New York City is based on Eight.[49] In the fall of 1923 Picasso returns to Variation Seven which he uses until the fall of 1935. From the fall of 1935 through the summer of 1941 he uses Eight. He will then use Seven till 1965 when he returns to Eight which he will use until his death in 1973. I am aware of only one occasion after *les Demoiselles* where he uses more than one perspective for the same work. This is *Girl Before a Mirror*, 1932, The Museum of Modern Art, New York City. The Variation Seven girl pops out at us while her Variation Eight image in the mirror floats mysteriously away.[50]

My understanding of Picasso's perspectives has provided me both with an entry into his art and also a tool for better understating the whole history of art and in particular the work of his great progenitor, Paul Cézanne to which I now turn.

"Fixing" Cézanne

Cézanne Perspective

When I compare Paul Cézanne's *Large Bathers*, R856, The Barnes Foundation, Philadelphia, to Emile Bernard's 1904 photograph of Cézanne seated before this painting I come to a disturbing conclusion. The Barnes *Large Bathers* appears to me to not be in the manner of Paul Cézanne, not based on Cézanne perspective while the painting in the photograph is. Previously I had suspected a number of Cézannes of not being by Cézanne, but the Barnes *Bathers* was certainly a Cézanne. So this was something else, a Cézanne made "not" a Cézanne by certain elements, mostly outlines, being changed using a perspective not the one I find to have been used by Cézanne. Cézanne's perspective as I see it, his way of seeing and composing his works, begins with a static aligned large ego wide view of the composition. In this context the large ego is related to a individual shape with an adjacent shape seen related too the not aligned ego and so disconnected. Finally the large ego is related to this shape and so forth. In this way Cézanne can individualizes his shapes in a composition that is held together by a wide view. In addition Cézanne forms are seen in a surrounding space and diminished in scale. A Cézanne composition is a sequence of disconnected highly inventive shapes bound together by an overall view. (Around 1885 Cézanne begins fixing the position of his ego).

The Betrayal

Perspective structures a work of art, gives it coherence. Changing a work using a perspective alien to that used in its making can greatly diminish it. I see outlines changed using frontal perspective in at least 90 Cézanne paintings in the Rewald catalogue.[51] Others including the Barnes *Bathers* R856, I find more completely repainted again using frontal perspective. How did this happen? Did Cézanne,

aging and diabetic, after many years defending his individuality against some of the harshest criticism any artist has had to face begin altering his works with an alien perspective all the while continuing to produce masterpieces using his original perspective? I find it hard to believe.[52] If not Cézanne then who? My guess is that Ambroise Vollard, Cézanne's dealer, who along with Cézanne's son Paul who was not an artist it seems to have had the necessary access, had altered 93 paintings in the Rewald catalogue.[53] In addition to Vollard I find seven others, all artists, altering Cézannes in their possession. These are: Camille Pissaro, four; Edgar Degas, six; Claude Monet, two; Emile Schuffenecker, two; Egisto Fabbri, twelve; Henri Matisse, four and Pablo Picasso, two. So as I see it Cézanne was betrayed by his "trusted" dealer, four fellow impressionists, an early supporter and collector and the two most famous artists of the twentieth century. [54]

1859-1872

Cézanne was born in 1839. There are paintings by him in the Rewald catalogue beginning in 1859. From here to the spring of 1872 when he went to work with Pissaro I find three significant loses probably to Vollard. The first is R121, *The Abduction*, 1867, on loan to the Fitzwilliam Museum, Cambridge. Here I see the contours of struggling central figures, a man and a woman, redrawn using frontal perspective which leaves them a anatomical jumble. Another early loss is R136, *The Black Clock*, 1867-1869, Private Collection, long regarded a Cézanne masterpiece. Could it be that this reputation ironically rests on conventualized frontal perspective outlines? Be that as it may, I see this is as no longer in the manner of Cézanne. A third early loss is R149, *Young Girl at the Piano, Overture to Tannheuser*, 1869-70, Hermitage Museum, St. Petersburg in which Cézanne placed his sisters in what would have been an intricately balanced domestic interior. I see however frontal perspective outlines compromising both figures and furniture. Only the wallpaper and fabric on a chair look to me to be intact. In addition to these three early losses, owed I suspect to Vollard, we have R120, *The Negro Scipion*, 1867, Museo de Arte Sao Paulo, Assis Chateaubriand, which once belonged to Claude Monet and which on the basis of what I see as fixed ego Attic perspective I suspect to have been heavily repainted by Monet.[55] Finally we have two well known works from the end of the early years which I believe misattributed. These are R179, *The Wine Depot*, 1872, Private Collection and R182, *Portrait of Cézanne*, 1872, Musée d'Orsay. Theses I see as based on the Hellenic perspective used by Cézanne's friend the painter Achille Emperaire.[56]

1872-82

From the "Pissaro decade", 1872-82, come ten more paintings I believe altered at the behest of Vollard, R201, R280, R291, R293, R299, R305, R407, R428, R452 and R464. I also find three I think altered by Camille Pissaro, R302, R313 and R385; three by Edgar Degas, R346, R369 and R416; six by Egisto Fabbri, R124, R324, R341, R425, R429 and R438; one by Henri Matisse, R360 and two by Pablo Picasso, R365 and R395. I also find R188 not to be by Cézanne but by Paul Renoire. I find one of the losses to Vollard is to be R201, *The House of Pierre Lacroix*, 1872, National Gallery of Art, Washington, DC. This work from Cézanne's first summer with Pissaro was shown at the First Impressionist Exhibition, 1879. What remains today is for me only a suggestion of what once was. Look to R220, *Houses at Auvers*, c.1873, Fogg Museum, Cambridge, MA, to see how, early on, Cézanne eclipsed impressionism by the inventiveness of his brushwork, form and color. From the end of the Pissaro years comes R407, *Poplars*, 1879-80, Musée d'Orsay, I think this is another loss probably to Vollard and frontal perspective outlines. As originally conceived it would have anticipated Cézanne of the eighties and nineties, the "classical" Cézanne ("classical" in the sense that Cézanne's compositions from this time appear more harmonious and geometric). Compare *Poplars* to, *The Bridge at Mainecy*, R436, 1879-80, Musée d'Orsay, where Cézanne's unique geometry prevails in all it strength and subtlety. Three Cézannes from the seventies I believe altered by Pissaro who once owned them and because I see them now largely based on the fixed ego frontal perspective used by Pissaro. These are *Still Life with a Soup Tureen*, R302, ca. 1877, Musée d'Orsay, *Two Vases of Flowers*, R313, 1877, private collection and *Portrait of Paul Cézanne*, R383, ca. 1877, Musée d'Orsay.[57] I believe Edgar Degas, on the basis of the Hellenic perspective he used and his one time ownership to be responsible for reworking R346, *Seven Apples*, ca. 1878, Keynes Collection, on loan to the Fitzwilliam Museum, Cambridge; *Bather with Raised Arms*, R369, 1874-80, Private Collection and *Portrait of Cézanne*, R416, 1879-80, Private Collection.[58] John Rewald suggests that the frequently reproduced, *Panoramic View of Auvers*, R221, 1873-4, Chicago Art Institute, once belonged to the Cézanne supporter Dr. Paul Gachet. I see this as a frontal perspective composition of dubious merit and not a Cézanne. It could well be by one of the Gachets, father or son.[59] I see four Cézanne paintings from this period as presumably repainted by the Italian American amateur painter and early Cézanne collector, Egisto Fabbri, their one time owner. Of the four, I think our greatest loss is *Madame Cézanne in a Striped Skirt*, R324, 1877, The Museum of Fine Arts, Boston which I see as quixotically repainted using using frontal perspective. Left untouched are the wall paper, the right side of her red armchair

and her skirt. Compare this to a true Cézanne, *Madame Cézanne Sewing*, R323, c. 1877, The Nationals Museum of Art, Stockholm, for the beauty of its geometry, now so lacking in what I see as the confused forms of the Boston painting. Another loss to Fabbri is *Houses in Provence*, R438, National Gallery of Art, Washington, DC. I suspect that this well known "Cézanne", much admired for its geometry is now more Fabbri than Cézanne and has done much to obscure the real Cézanne. Sadly find such important losses to Fabbri continue into the eighties.[60]

A most distressing and confusing case is that of the *Three Bathers*, R360, 1876-77, Musée de la Ville de Paris, Petite Palais. This famous "Cézanne" was given to the City of Paris in 1936 by Henri Matisse, who said it had inspired him. Be that is as it may, I see it as heavily repainted using a Matisse perspective and no longer as a Cézanne,[61] Just as disturbing is the case of two "Cézannes" in the Picasso Museum Paris, R365, *Five Bathers*, 1877-78 and R395, *l'Estaque Seen Through Trees*, 1878-79. Both I see as largely repainted using a perspective peculiar to Picasso.[62] Compare Picasso's R365 to R364, a similar, intact, five bather Cézanne composition and R395 to R396, a similar intact Cézanne landscape. These Picasso\Cézannes have merit as Picassos, but I see them as poor things compared to real Cézannes.

1882-95

In the midst of Cézanne's career is the period 1882-95, spent working around Aix. From here come 40 paintings I see as altered probably at the behest of Vollard (see appendix nos. R513 through R804). I also see as altered; two by Pissaro, R455 and R577; one by Degas, R557; one by Monet, R666; one by Matisse, R576; one by Emile Schuffenecker, R537 and four by Egisto Fabbri; R551, R569, R659 and R717. I suspect R530, *l'Estaque, Rocks, Pines and The Sea*, ca. 1880, Staatliche Kunsthalle, Karlsruhe to be a loss to Vollard. Compare this to R531, *L'Estaque and The Golf of Marseilles*, ca. 1880, on loan to the Fitzwilliam Museum, Cambridge. I see the incongruous outlines imposed on the Karlsruhe painting destroying the dynamic balancing that so distinguishes the Cambridge painting. The same contrast I find exists between R626, *The Golf of Marseilles Seen from L'Estaque*, 1885-86, The Art Institute, Chicago and R625, *The Golf of Marseilles Seen From L'Estaque*. The Metropolitan Museum of Art, New York. The New York painting is a beautifully realized, serenely coherent and wonderfully diverse work of art. From the plunge to horizontal roof tops in the lower right to the vertically accented central fore and middle ground buildings to the alternating green and gold headlands on the left that give way to a subtly varied plane of blue water, to the violet solidity of the the hills of the Marseillivegre and finally to an azure sky all is luminously harmonious thanks to the all seeing eye of Paul Cézanne. I see new outlines leaving the Chicago painting no such place. In New York the whole supports the parts. In Chicago I see

the whole lost and so almost all is lost. It is also significant that the coherence of the New York painting is reinforced by a fixed ego. I find also lost to Vollard R573, *House Near Gardanne*, 1886-90, Indianapolis Museum of Art and R572, *Hamlet in the Countryside Near Gardanne*, 1886-89, Private Collection. Compare these to R575, *Environs of Gardanne*, 1886-90, Private Collection; where things are as they should be. Of Cézanne's three studies of Gardanne, R569, *Gardanne, Horizontal View*, c. 1885, The Barnes Foundation, Philadelphia, R570, *Gardanne, Vertical View*, c. 1886, The Metropolitan Museum of Art, New York and R571, *Gardanne, Afternoon*, c. 1886, The Brooklyn Museum, New York, NY, I see only the Metropolitan Museum's as intact. Outlines in the Brooklyn painting I see as changed while I see the Barnes as heavily repainted. The difference I suspect us between a work circumspectly altered for Vollard, R571, and the heavy hand of Egisto Fabbri, R569. I also judge R551, the well known *Chestnut Trees at Jas de Bouffon*, 1885-86, Minneapolis Institute of Art, to be a loss to Fabbri. Compare this to R522, *Bare Trees at Jas de Bouffon*, 1885-86, National Museum Western Art, Tokyo. The calligraphic wizardry I see in the Tokyo treetops is lost in a jumble of lines in Minneapolis. The New York Museum of Modern Art's Cézanne "icon", R555, *Large Bather*, ca. 1885, appears to me to be extensively retouched, probably at the behest of Vollard. Taking it from the top I find his hair is as Cézanne left it; but, his face to be in disarray, brows, eyes, nose and mouth redrawn and his jaw and chin cut across by heavy prussian blue lines. Similar dark outlines impair the torso, arms, hands, trunks, legs and feet leaving a sequence of disconnected, anatomically absurd parts while the scumbling of the background destroys the relationship between figure and landscape. He is to my "eye" is no longer a Cézanne. Compare this bather to its forebear, the central bather of R211, *Bathers at Rest*, 1876-77, the great, *Caillebotte Bathers*, in the Barnes Foundation. The Barnes bather is if anything more radical in appearance, but follow Cézanne's perspective and he becomes a coherent assemblage of forms that fit beautifully into equally unconventional surroundings. Two other bather compositions I suspect lost to Vollard are R553, *Bathers Before a Tent*, 1883-85, Staatsgalerie, Stuttgart and R665, *Bathers*, ca. 1890, Musée d'Orsay. As best I can determine these works as seen in a Vollard photograph of the Cézanne room of the 1904 Salon d'Autome were still intact at the time. Vollard would seem to have had them "fixed" after they came back from the show.[63] The multi figure bather composition R666, St. Louis Museum of Art, ca. 1890, is I think another 'lost' Cézanne. But in this case the culprit, on the basis of perspective and ownership, would seem to be Claude Monet.[64] In the early nineties Cézanne painted a group of pictures of men playing cards using as models workers from the Jas de Bouffon estate; R704 through R717. I see R706, the largest of these, *Card Players*, 1890-92, Barnes Foundation, Philadelphia as lost to us. I

see frontal perspective outlines rendering its forms detached and crudely angular. Compare this to R707, *The Card Players*, 1890-92, The Metropolitan Museum of Art, New York; a monumentally coherent Cézanne, Poussin revisited.[65] Cézanne's wife, Hortense, sat many times for him and most of these portraits are intact. One that as I say above is a loss to Fabbri. is Boston's R324. Another I see as changed is R576, 1886-87, Philadelphia Museum of Art. This time the culprit would seem to have been Henri Matisse.[66] Lost I presume to Vollard are R683, *Madame Cézanne, 1888-90*, Barnes Foundation, Philadelphia and R655, *Madame Cézanne in a Yellow Chair*, 1888-90, Metropolitan Museum of Art, New York. Vollard's agent I think has left us with what I see to be a cockeyed Hortense, with mangled hands and disarranged dress in a room that collapses around her. Again I see the "fixing" of Cézanne's perspective as systematically destroying Cézanne's perspective. Around the year 1890 Cézanne painted four much admired studies of a young Italian boy, a model, wearing a red vest: R656, *Boy in a Red Vest*, 1888-90, Barnes Foundation, Philadelphia; R657, *Boy in a Red Vest*, 1888-90, The Museum of Modern Art, New York; R658, *Boy in a Red Vest*, 1888-90, E. G. Bührle Collection, Zurich and R659, *Boy in a Red Vest*, 1888-90, National Gallery of Art, Washington, D.C. Of the four I find that only R657 in the Museum of Modern Art, as an intact Cézanne. I see R656 and R658 as probably Vollard victims, while R659 in the National Gallery appears to me to be an Egisto Fabbri repaint. Rose Conil, Paul's married sister lived in a country house at Bellevue just east of Aix. The house and the surrounding countryside provided Cézanne with motifs in and about the year 1890. Of these Bellevue paintings I see R692, *Pigeon Tower Bellevue*, The Cleveland Museum of Art and R694, *Pigeon Tower Bellevue*, Private Collection as altered probably for Vollard. Two other landscapes associated with Bellevue also appear to me to have Vollard sponsored "corrections", R761, *Red Earth and Big Pine*, 1890-95, Hermitage Museum, St. Petersburg and the equally well know R718, *Road Provence*, 1890-95, National Gallery of Art, London.[67] During his lifetime some of Cézanne's most admired works were his still lives. Nevertheless, Vollard I suspect had several of these "fixed." Most notably: R800, *Basket of Apples*, ca. 1893 The Chicago Art Institute; R804, the *Unfinished Still Life*, 1895-98, The Museum of Modern Art; New York. Frontal perspective outlines in each case I see "ruining" the work. This brings us to the case of two "classic" still lives I believe altered by Edgar Degas: R681, *The Liqueur Bottle*, c.1890, Private Collection, once the property of Mary Cassat and R772, *The Bottle of Peppermint*, 1893-95, National Gallery of Art, Washington, DC. Both I see as been extensively repainted in a style suggesting Degas and as based on the Hellenic perspective used by Degas. On the other hand I find R675, *The Blue Vase*, 1889-90, Musée d'Orsay to be a work entirely by Degas, a "true" Degas.[68]

1895-1906

The final stage of Cézanne's career begins in November 1895 with the Cézanne show at Ambroise Vollard's Paris gallery. At this time Cézanne emerges from obscurity to become a figure in the Paris art world and beyond. Cézanne's style does not change at this time, but it does during the following decade, perhaps in part due in part to diabetes and diminished eyesight. He begins using larger patches of color which in some cases are broken down to form highly fragmented, densely painted compositions that leave impressionism further behind. Among such paintings are views of the Chateau Noir, its surroundings and Mount Sainte-Victoire seen from near by his new studio just north of Aix at Les Lauves. In these works I find Cézanne recapturing his youthful exuberance which he joins to his twenty years of working from nature. From these late years I count 29 paintings I see as altered, probably for Vollard, appendix, R805 through R953. In the summer of 1896 Cézanne goes on vacation with his wife and son to Annecy. There he paints water colors and an oil, a view across the lake R805, *The Lake of Annecy*, Courtauld Institute Galleries, London. The ragged appearance of this painting I think reflects not Cézanne's lack of interest in the picture-post-card motif, but to awkward, frontal perspective "corrections" applied I think at the behest of Vollard. I see as a most telling example of Vollard's meddling Vollard's own portrait, R811, *Portrait of Ambroise Vollard*, 1899, City of Paris Collection, Petite Palais. Vollard writes that Cézanne labored long and hard on this work and then left it unfinished. I see its present state not what Cézanne left.[69] I see many of the outlines as refashioned using frontal perspective. The *Portrait* remained in Vollard's personal collection until his death in 1923 when it passed to the City of Paris. Its sad transformation tells me that Vollard truly believed Cézanne needed "improving". Another I think major loss probably to Vollard is R821, *Young Man With A Skull*, 1898-1900, Barnes Foundation, Philadelphia. What was poetic I see as now pathetic its meaning being dependent on form. Also lost probably to Vollard are two studies of skulls, R821, *Three Skulls, 1898-1900, Detroit* Institute of Arts and R822, *Pyramid of Skulls*, 1898-1900, Private Collection. Cézanne's final studies of his gardener, Vallier, are intact including R954, 1906, Private Collection. Cézanne found many late motifs in the Arc Valley including the woods and ledges around the Chateau Noir, the abandoned quarry at Bibémus and views from around his studio at Les Lauves.[70] Of the Bibémus paintings I see as compromise by frontal perspective outlines thanks I believe to Vollard are R797, *Bibémus Quarry*, 1895, Museum Folkwang, Essen; R799, *Red Rock*, 1895, Musée d'Orangerie, Paris and the well known R837, *Mount Sainte Victoire from the Bibémus Quarry*, ca. 1895, Baltimore Museum of Art. The same is true for R763, *The Millstone*, 1892-04, Philadelphia Museum of Art, a motif from the park of the Chateau Noir. Compare this to R764, *Millstone and Cistern*, 1892-04, Barnes Foundation,

Philadelphia, an intact study of a similar motif. Frontal perspective corrections, thanks probably to Vollard, have also cost us R906, *Pines and Rocks*, ca. 1897, The Museum of Modern Art, New York, which Rewald tentatively identifies as a motif near the Chateau Noir and R903, *Rocks and Pines*, Barnes Foundation, Philadelphia, a similar motif that Rewald lists as possibly coming from the Vollard Gallery. Compare these to the beautifully realized R775, *Rocks at Fontainebleau*, ca, 1893, Metropolitan Museum of Art, New York. Among the densely painted intact works from Cézanne's final years are several views of the Chateau Noir including, R940, *Chateau Noir* 1903-04, Museum of Modern Art New York, R941, *Chateau Noir*,1903-04, Picasso Museum, Paris and R937, *Chateau Noir*, 1900-04, National Gallery of Art, Washington, DC. I see as lost R909, *Rocks Near the Grottoes above the Chateau Noir*, ca. 1904, Musée d'Orsay. In this case I think the culprit is its one time owner, Henri Matisse.[71] Of Cézanne's late views of Mount Sainte-Victoire I find the following to be losses probably to Vollard: R902, *Mount Sainte-Victoire Seen from the Chateau Noir*, ca. 1901, The Edsil and Eleanor Ford House, Grosse Pointe Shores, Michigan; R910, *Mount Sainte-Victoire Seen from Lauves*, 1902-06, Pearlman Foundation, on loan to Princeton University Museum, NJ; R911, *Mount Sainte-Victoire Seen from Les Lauves*, 1902-04, Philadelphia Museum of Art; R914; *Mount Sainte-Victoire*, 1902-04, Private Collection and R915, *Mount Sainte-Victoire*, The Annenberg Collection, Metropolitan Museum of Art, New York. This brings us back to Cézanne's late *Large Bathers*. The London painting, *R855, Large Bathers*, 1904-6, National Gallery, London and the Barnes painting, R856, *Large Bathers*. 1904-6, Barnes Foundation, Philadelphia, I see as reconfigured I think thanks to Vollard. R857, *Large Bathers*, 1904-06, Philadelphia Museum of Art, is a pristine Cézanne, a wonder, in which every form, every brush stroke celebrates Cézanne's individuality while remaining part of a coherent whole when seen Cézanne's way.[72]

This analysis of Cézanne paintings in the Rewald catalogue is intended to right some of the wrong done this great artist and hopefully to make the work more available to us all. It is my contention that great art is a driving force in the history of art and to a large extent the work of individuals. Cézanne was a great and influential artist and although some have produced works resembling his none has adopted his all important perspective.[73] Cézanne's influence seems to have been more in the way of ideas about individuality and unconventionality. At this time when ideas rather than form seems to be driving the history of art if I am right about the changes to Cézanne did these "fixer uppers" by obscuring the real Cézanne help promote this direction? Be that as it may, it is a mistake to confuse a work of art with ideas about it. A work of art is a world governed by the visual ego, a world in itself.

Both Cézanne and Picasso used perspectives based on disconnection. Disconnection acts to fracture a work and can impede the artist, but both Cézanne and Picasso made disconnection a great asset. Cézanne uses it with a wide view to create works that are coherent yet have great visual diversity. Sadly I see a large number of Cézanne's works disfigured by repainting. Disconnection is also a part of Picasso's unique to him new perspective used. I addition to a magnificent body of work I believe Picasso's perspective inventions, his voyage of discovery, lead us to a better understanding of art and of ourselves.

Appendix.

Cézanne paintings in the Rewald Catalogue Raisonné, that I see as altered, or misattributed.

1. Paintings I see as retouched or repainted perhaps at the behest of Ambroise Vollard:

R121, *The Abduction,* Keynes Collection, on loan to Fitzwilliam Museum, Cambridge.

R136, *The Black Clock,* Private Collection.

R149, *Young Girl at Piano,* Hermitage Museum, St. Petersburg.

R201, *The House of Pére Lacroix,* National Gallery of Art, Washington, DC.

R280, *Village on the Water,* Barnes Foundation, Philadelphia.

R291, *Afternoon in Naples,* Australian National Gallery, Canberra.

R393, *The Seine at Bercy after Guillaumin,* Hamburg Kunsthalle.

R299, *The Eternal Feminine,* J. Paul Getty Museum, Malibu, CA.

R305, *Fruits et Boite a Poudre,* Private Collection.

R407, *Poplars,* Musée d'Orsay, Paris.

R420, *Comptoir, Pommes et Miche de Pain,* Private Collection

R428, *Milk Can and Lemon,* Cincinnati Museum of Art.

R452, *Standing Bather from the Back,* Private Collection.

R464, *Son of the Artist,* Private Collection.

R513, *Plain, Provence,* on loan to the Sammlung Villa Flora, Winterthur.

R516, *L'Estaque, the Morning,* The Israel Museum, Jerusalem.

R525, *The Gardener,* Barnes Foundation, Philadelphia.

R530, *L'Estaque, Rocks, Pines and Sea,* Staatliche Kunsthalle, Karlsruhe.

R533, Sketch for Portrait, Private Collection

R553, *Bathers Before a Tent*, Staatsgalerie, Stuttgart.

R555, *Large Bather*, Museum of Modern Art, New York.

R563, *Peaches and Pears*, Private Collection.

R571, *Gardanne, Afternoon*, Brooklyn Museum, New York.

R572, *House in the Countryside Near Gardanne*, National Gallery of Art, Washington, DC.

R573, *House Before Mount Sainte-Victoire*, Indianapolis Museum of Art.

R619, *Harlequin*, Private Collection.

R626, *The Golf of Marseilles Seen from L'Estaque*, Art Institute, Chicago.

R627, *In the Forest of Fontainebleau*, Private Collection.

R629, *House and Trees*, Barnes Foundation, Philadelphia.

R632, *Hunter's Cabin Provence*, Barnes Foundation, Philadelphia.

R634, *Still life Before a Chest of Drawers*, Fogg Art Museum, Harvard University, Cambridge, MA.

R654, *Curtain*, Abegg Stiflung, Riggisberg.

R655, *Madame Cézanne in a Yellow Armchair*, Metropolitan Museum of Art, New York.

R656, *Boy in a Red Vest*, Barnes Foundation, Philadelphia.

R658, *Boy in a Red Vest*, Sammlung E. D. Bührle, Zurich.

R665, *Bathers*, Musée d'Orsay, Paris.

R677, *Still Life*, Private Collection.

R682, *Reclining Boy*, UCLA, Armand Hamer Museum of Art and Cultural Center.

R683, *Portrait of Madame Cézanne*, Barnes Foundation, Philadelphia

R687, *Alle, Jas de Bouffan*, Private Collection.

R692, *Pigeon Tower, Bellevue*, The Cleveland Museum of Art.

R694, *Pigeon Tower, Bellevue*, Private Collection.

R695, *The Aqueduct*, Pushkin Museum, Moscow

R702, *Terra-cotta Pots and Flowers*, Barnes Foundation, Philadelphia.

R705, *Man With a Pipe*, Private Collection.

R706, *Card Players*, Barnes Foundation, Philadelphia.

R711, *Man with a Pipe*, National Gallery of Art, Washington, DC.

R726, *Reflections in Water*, Private Collection.

R747, *Bathers*, Private Collection.

R760, *The Cracked House*, Metropolitan Museum of Art, New York.

R761, *Large Pine and Red Earth*, currently at the Hermitage Museum, St. Petersburg.

R763, *The Millstone*, Philadelphia Museum of Art.

R767, *Mount Sainte-Victoire*, Barnes Foundation, Philadelphia.

R781, *Woman with a Coffee Pot*, Musée d'Orsay, Paris.
R782, *Still Life with Plaster Eros*, Nationalmuseum, Stockholm.
R797, *The Quarry at Bibémus*, Museum Folkwang, Essen.
R799, *The Red Rock*, Musée du Orangerie, Paris.
R800, *Basket of Apples*, Art Institute, Chicago.
R804, *Still Life*, Museum of Modern Art, New York.
R805, *The Lake of Annecy*, Courtauld Institute Galleries, London.
R806 *Portrait of a Girl with a Doll*, Beggruen Collection, Berlin.
R807, *Portrait of a Young Girl*, whereabouts unknown.
R811, *Portrait of Ambroise Vollard*, Musée de la Ville de Paris, Petite Palais.
R821, *Three Skulls*, Detroit Institute of Arts.
R822, *Pyramid of Skulls*, Private Collection.
R825, *Young Man with Skull*, Barnes Foundation, Philadelphia.
R830, The *Roofs*, Private Collection.
R832, *Church at Montigny-sur-Loing*, Barnes Foundation, Philadelphia
R837, *Mount Sainte-Victoire Seen from Bibémus*, Baltimore Museum of Art.
R841, *Plate of Peaches*, Private Collection.
R855, *Large Bathers*, National Gallery, London.
R856, *Large Bathers*, Barnes Foundation, Philadelphia.
R858, *Bathers*, Private Collection.
R861, *Bathers*, Baltimore Museum of Art.
R877, *Bathers*, Private Collection.
R899, *Mount Sainte-Victoire*, Hermitage Museum, St. Petersburg.
R902, *Mount Sainte-Victoire*, Ford House, Grosse Pointe Shores, MI.
R906, *Pines and Rocks*, Museum of Modern Art, New York.
R910, *Mount Sainte-Victoire*, Private Collection.
R911, *Mount Sainte-Victoire*, on loan to the Philadelphia Museum of Art.
R912, *Mount Sainte-Victoire*, Private Collection.
R915, *Mount Sainte-Victoire*, Private Collection and Metropolitan Museum of Art, New York.
R930, *Turning Road*, National Gallery of Art, Washington, DC.

2. Paintings listed in the Rewald catalogue as possibly from the Vollard gallery that I suspect retouched or repainted at the behest of Vollard:
R718, *Road in Provence*, National Gallery, London.
R903, *Rocks and Trees*, Barnes Foundation, Philadelphia.

3. Paintings that I believe repainted by Edgar Degas perhaps at the behest of Ambroise Vollard:

R346, *Seven Apples*, Keynes Collection on load to the Fitzwilliam Museum, Cambridge.
R369, *Bather with Raised Arms*, Private Collection.
R416, *Portrait of Cézanne*, Private Collection.
R557, *Two Fruits*, Private Collection.
R681, *The Liqueur Bottle*, Private Collection.
R772, *The Peppermint Bottle*, National Gallery of Art, Washington DC.

4. Paintings from the Rewald Catalogue I think repainted by Camile Pissaro:
R302, *Still Life with Soup Pot*, Musée d'Orsay, Paris.
R313, *Two Vases of Flowers*, Private Collection.
R385, *Portrait of Cézanne*, Musée d'Orsay.
R455, *Struggle of Love, I*, Private Collection.
R577, *Portrait of Jules Peyron*, Private Collection.

5. Paintings repainted I believe by Claude Monet:
R120, *The Negro Scipion*, Museu de Arte de São Paulo assis Chateaubriand.
R666, *Bathers*, Saint Louis Art Museum.

6. Paintings repainted, I believe by Egisto Fabbri:
R124, *Satyrs and Nymphs*, Private Collection.
R324, *Madame Cézanne in a Striped Skirt*, Museum of Fine Arts, Boston.
R34l, *Apricots and Cherries*, Private Collection.
R425, *Bowl and Milk Can*, Bridgestone Museum of Art, Tokyo.
R429, *Milk Can and Lemon, II*. Private Collection.
R438, *House in Provence*, National Gallery of Art, Washington DC.
R551, *Chestnut Trees in Winter*, Minneapolis Institute of Arts.
R569, *Horizontal Gardanne*, Barnes Foundation, Philadelphia
R624, *House by the Marne*, Private Collection.
R659, *Boy in a Red Vest*, National Gallery of Art, Washington, DC.
R717, *Bellevue Landscape*, The Phillips Collection, Washington, DC.
R724, *Reflections in Water*, National Gallery of Art, Washington, DC.

7. Paintings repainted, I believe by Emile Schuffenecker:
R444, *The Bay at L'Estaque*, Philadelphia Museum of Art.
R537, *Large Pine. Private Collection.*

8. Paintings I believe repainted by Henri Matisse:
R360, *Three Bathers*, Musée de la Ville de Paris, Petit Palais.

R576, *Portrait of Madame Cézanne*, Philadelphia Museum of Art.
R647, *Fruits and Leaves*, Private Collection.
R909, *Rocks and Grottos*, Musée d'Orsay. Paris.

9. Paintings I believe repainted by Pablo Picasso:
R365, *Five Bathers*, Picasso Museum, Paris.
R395, *The Sea at l'Estaque Seen Through Trees*, Picasso Museum, Paris.

10. Paintings in the Rewald Catalogue I believe on the basis of perspective to be misattributed.
R8, R13, R21, R43, R47, R71, R73, R84, R88, R96, R110, R129, R131, R143, R159, R170, R172, R173, R179, R182, R188, R195, R199, R205, R206, R207, R208, R209, R210, R2ll, R212, R213, R221, R223, R225, R227, R231, R232, R233, R336, R241, R255, R265, R266, R274, R277, R298, R304, R306, R312, R315, R317, R318, R319, R322, R327, R330, R335, R336, R347, R352, R353, R355, R356, R357, R358, R411, R412, R424, R446, R448, R469, R473, R480, R489, R493, R494, R498, R499, R548, R597, R616, R710, R733, R737, R750, R752, R675, R802, R820, R850, R866, R934, R935, R936, R944 and R948.

Picasso Notes

1 I know of no previous explanations of the works of Picasso and Cézanne consistent with these presented here including ny own, Peter Moak, *Seeing Picasso*, 2006, Trafford Publishing, Victoria, Canada.

2 The visual ego described here differs from that of Ernest Mach who decribes what he calls the phenomenal ego which James J. Gibson calls the visual ego. In both cases the ego is a visual world as seen from one eye that includes parts of the viewer. I describe the visual ego as an imagined presence, a self, in relation to which we see the visual world. See James J. Gibson *The Perception of the Visual World*, 1950, 27 and 225.

3 The explanation of Picasso's works has evolved over the years in stages. Daniel-Henry Kahnweiler's *The Rise of Cubism*, first published 1920. Kahnweiler calls the cubism of Picasso and Braque rational, a combination of abstract forms and real details. Kahnweiler's explanation does not refer to specific works and is not consistent with how I see and describe Picasso's works here. A second stage is exemplified by Alfred Barr's *Picasso: Fifty Years of His Art*, 1946. Barr supports Kahnweiler's idea of a method and then contradicts this by describing works as disintegrated images. By this time Picasso's work is largely explained by reference to other works. A third stage begins with Robert Rosenblume's *Cubism and Twentieth Century Art*, 1960 and is epitomized in Leo Steinberg's "What About Cubism" in *Picasso in Perspective*, 1975, G. Schiff ed. These writers reject the idea of a method and see the works as deliberately ambiguous and contradictory and explain them with an ever widening sphere of influences. The fourth stage which prevails today accepts the works as ambiguous and contradictory and interprets them in the the context of cultural, biographical, political, historical, philosophic and or linguistic influences depending on the author. For a biographical approach see Mary Martha Gedo, *Art as Autobiography*, 1980. For a political explanation see Patricia Leighton, *Re-Ord-ering the Universe: Picasso and Anarchism. 1897-1914*, 1989. For a feminist reading see Anna C. Chave "New Encounters with *Les Demoiselles d'Avignon*, Gender, Race and the Origins of Cubism," The *Art Bulletin*, 76, no. 4. 1964, 596. Other studies of Picasso's "cubism" include: Christine Poggi, *In Defiance of Painting; Cubism, Futurism and the Invention of Collage*, 1992; T. J. Clark, *Farewell to an Idea: Episodes from a History of Modernism*, 1999, Chapter 4, "Cubism and Collectivity",169; Pepe Karmel, *Picasso and the Invention of Cubism*, 2003 and Lisa Forman in a review of four books concerning Picasso: Elizabeth Cowling, *Picasso Style and Meaning*, 2002; Pepe Karmel (as above); Natasha Staller, *A Sum of Distructions, Picasso's Cultures and the Creation of Cubism*, 2001 and Jeffrey Weis, Valerie Fletcher and Kathryn Tuma, *The Cubist Portraits of Fernande Olivier*, exh. cat. 2003, National Gallery of Art, Washington D.C., *Art Bulletin*, 2004, Vol. LXXXVI, no. 3, 614. I find none of the above descriptions and explanations to be correct. I find semiology a linguistic approach to be particularly ineffective. See Rosalind Krauss, "The Motivation of the Sign" and Yve-Alain Bois, "The Semiology of Cubism" 169-208, both in Lynn Zelevansky and William Rubin, *Picasso and Braque a Symposium*, Museum of Modern Art, 1992, New York City.

For Cézanne criticism see Joseph J. Rishel and Francoise Cachin "A Century of Cézanne Criticism" in *Cézanne*, exh.cat. Francoise Cachin, Isabelle Cahn, Walter Feilchenfelt, Henri Layrette and Joseph Rishel (Harry N Abrams Inc., New York, in association with the Philadelphia Museum of Art, 1996) 23-75 and George Heard Hamilton "Cézanne and His Critics" in *Cézanne: The late Work*, exh. cat. William Rubin ed. (The Museum of Modern Art, New York, 1977) 139-147. Cézanne criticism has evolved from being largely negative, based

on Cézanne's supposed perspective "flaws" to largely positive, based on various interpretations of these "flaws", which is where we are today. It is hard to find value in explanations not based on works seen correctly.

4 For a biography of Picasso see John Richardson, *A Life of Picasso*, vol. I-III. 1881-1906, 1991, *A Life of Picasso: The Cubist Rebel*, Vol. II, 1996 and *A Life of Picasso: The Triumphant Years*, Vol. III, 2007. For *Science and Charity* see Vol. I, 8about

5 I find Picasso to have been dyslexic, a problem I have myself, because his works till the fall of 1901 are based on forms related to the not aligned ego. Picasso's overcomes this handicap when he begins using peripheral perspective in the fall of 1901.

6 See Pierre Daix, Georges Boudaille with Jean Rousselet, *Picasso: The Blue and Rose Periods*, 1967, 122, no. II 10, on Picasso's *Moulin de la Galette*.

7 See Ron Johnson "Primitivism in the Early Sculpture of Picasso" *Arts Magazine*, Vol. 49, no. 10, 1975, 64, for the influence of Gauguin on Picasso, Picasso's visit to Paco Durio's studio and the drawing *Parisienne with Exotic Figures*.

8 See Bernard Dornival, "Sources of the Art of Gauguin from Java, Egypt and Ancient Greece," *Burlington Magazine*, 93, No 577, 1951, 118 for the influence of Indonesian art on Gauguin. See also M. Maligne, *Letres de Gauguin*, 1946, 157, LXXX for a letter from Gauguin to Emil Bernard on Gauguin's visits to the fair.

9 See C. Frésches-Thory, *"Portrait of a Woman with Still Life by Cézanne,"* in *Art of Paul Gauguin*, exh, cat., 1988, National Gallery of Art, Washington D.C. 192, 111, for a discussion of the relationship between Gauguin and Cézanne.

10 See Daix and Boudaille (as in no. 6) 197, for *Blue Room*.

11 See Daix and Boudaille (as in no. 6) 229. for *The Blind Man's Meal*. See also Elizabeth Cowling and John Golding, *Objects into Sculpture*. exh, catalogue (London, The Tate Gallery,2994) 231 for the sense of touch in *The Blind Man's Meal*.

12 See Daix and Boudaille (as in no. 6) 308, nos. XV 57-61, for drawings for *Peasants and Oxen* based on peripheral perspective including one in a letter to Gertrude Stein, August 17, 1906.

13 See Daix and Boudaille (as in no. 6) 324, no. XV 115, for *Two Nudes*. See Helen Seckel, ed. *Les Demoiselles d'Avignon*, vol. I, exh. catalogue, Picasso Museum, 1988, Carnet 1, 104 for two drawings related to *Two Nudes*. These drawings based on the third perspective used by Picasso, numbers 13R, 24R and 26R are oddly compartment as if Picasso was searching for a new way to subdivide images.

14 See Richardson (as in no. 4) vol. I, 403, for the influence of the Cézanne and Matisse portraits on Picasso. See Irene Gordon, ed. *Four Americans in Paris*. exh. cat., Museum of Modern Art, New York City, 1970, 89, for a photograph of these portraits on Gertrude Stein's wall.

15 See Daix and Boudaille (as in no. 6) 321, no XVI 10, for information about the *Portrait of Gertrude Stein*. See also 305, nos. XV 45-47, for three other works by Picasso where only the face has been changed using his third perspective. See James Johnson Sweeny "Picasso and Iberian Sculpture, *The Art Bulletin*, 23, no. 3. 1941, for the 1906 influence of Iberian Sculpture in on Picasso. See Robert S Lubar, "Unmasking Pablo's Gertrude: Queer Desire and the Subject of Portraiture", *The Art Bulletin*, 79, no. 1, 1997, 57, where the head of Gertrude Stein is seen as the product of gender instability.

16 See Seckel (as in no.13) Carnet 4, 170, for drawings of the figure with raised rectangular arms, 1R, 1V, 2R, 2V, 3R and 4R and Carnet 6, 186, a six figure Picasso's third perspective composition. Picasso could have seen Attic Geometric Vase painting at the Louvre. See E. Pottier, *Vases Antiques Du Louvre*, 1897, A 541 and Pepe Carmel, (as in no.1) 52 who points out the influence of Attic Geometric Vase painting on Picasso.

17 See Marie-Lowa Besnard-Benadoc, Michélet-Ribet and Hélen Seckel, *The Picasso Museum Paris, Paintings*, 1986, 40, no, 14 for drawing *Nude with Raised Arms from the Back*. See Pierre Daix and Jean Rousselet, *Picasso: Catalogue Raisonné de l'Oeuvre Peint, 1907-1916*, 1997, 194, no.18 for an oil sketch of *Figure from the Back*, based on Picasso Perspective Variation One dated May 07 which provides an aproximate date for the discovery of Picasso Perspective. See Seckel (as in no.13) Carnet 4, 171. 5V. 6V, 7R, 7V, 172, 8R, 8V, 9R, 9V, 10R and 174, 18V for drawings of the figure with rectangular arms based on Picasso Perspective Variation One.

18 See Seckel (as in no.17) Carnet 5, 182. This catalogue, *Exposition H. Daumier, Gallerie L. et P. Rosenberg Fils*, April 1907 contains three Variation Two drawings of this figure. See also Carnet 5, 314 for an infrared photograph of a Variation Two painting *Woman with Joined Hands* with underlying sketches based on Variation One. See Bernard-Bernadoc (as in no. 17) 40, no. 14 for this painting. See Michel Richet, The Picasso Museum Paris, *Drawings, Watercolors and Pastels*, (New York, Aarams, 1989) 72, nos. 137, 138 and 139 for drawings of this figure.

19 See G. Burgess, "The Wild Men of Paris" *The Architectural Record*, 27, no. 5, May 1910, 400-14, for a photograph showing this finial on Picasso's wall.

20 See Pierre Daiz "Histoire de *Demoiselles d'Avignon* Revise a l'Aide des Carnets de Picasso" in Seckel (as in no. 15) Carnet 4, 526 for the suggestion that the watercolor *Five Nudes* post dates the first version of *Les Demoiselles d'Avignon*.

21 Andre Malraux, *Les Tete d'Obsidiene*, 1947, 17 on Picasso's visit to the Trocodéro. The exact date of this visit is not known.

22 See Anatoly Podsik, *Picasso the Artist's Work in Soviet Museums*, 1972, 25, showing the Picasso Perspective Variation Two painting *Friendship*, the Hermitage, as dated 1908 indicating that Picasso continued to use Variation Two into 1908. Thus *Les Demoiselles d'Avignon* may have been finished using Variation Three later in the spring of 1908.

23 On *Landscape Rue des Bois* see Daix and Rousellet (as in no.17) 226.

24 See Pierre Daix, "The Chronology of Cubism: New Data on the Picasso-Braque Dialogue" in Zelevansky (as in no, 1), 311, fig. 7. Reproduced is a photograph of *Three Women* showing it as a Variation Two work and on 315, fig. 13 is the painting as a Variation Three work.

25 See Leo Steinberg "Resisting Cubism," *Art in America*, 66, no. 6, Dec. 1978, 114 and "The Polemical Part," *Art in America*, 67, March-April, 1979, 114. Steinberg sees the women as distorted and sexually ambiguous.

26 See Judith Cousins "Documentary Chronology," in Rubin ed., exh. cat. *Picasso and Braque: Pioneering Cubism*, Museum of Modern Art, New York City, 1989, 348 and Daix (as in no. 24) 306, for the possible date of the Picasso-Braque meeting. See Daix (as in no. 24) 311 for Braque's *Large Nude*.

27 See John Golding, *Cubism: A History and Analysis*, 1968, 134, for the spread of Cubism.

28 See William Rubin, *Picasso in the Collection of The Museum of Modern Art*, 1972, 138 on *The Reservoir*. Picasso's summer 1909 portraits of Fednande are based on Variation Four. The *Portrait of Fernande*, Museum of Modern Art, New York, I find to have been repainted in the fall of l909 using Variarion Five. The plaster *Head of Fernande*, fall 1909, is based on Picasso Variation Five. The bronze casts after the plaster that was sold to Ambroise Vollard are based on frontal perspective and not Picasso Perspective. See Jeffrey Weis, Valerie Fletcher and Kathryn A. Tuma, exh. catalogue, Picasso, *The Cubist Portraits of Fernande Olivier*, 2003, National Gallery of Art, Washington D.C.

29 See Rubin (as in no. 28) 62, for an explanatory drawing of *Still Life and a Liqueur Bottle*. See Natasha Staller on Picasso and cinema, *Sum of Destructions: Picasso's Cultures and the Creation of Cubism*, (Yale University Press, 2001) 143.

30 See Rubin (as in no. 28) 66 and John Richardson (as in no. 4), Vol. II, 150 for circumstances surrounding the painting of *Girl with a Mandolin* (Fanny Tellier).

31 For a photograph showing the Picasso Variation Five version of *Guitarist* see Daix and Rosselet (as in n.17) 357.

32 See Daix and Rousselet, 1997 (as in no. 17) 259 on the *Kahnweiler portrait*. See John Richardson, *Picasso an American Tribute*, exh. cat., Saidenberg Gallery, New York City, 1962, no,2 on the *Kahnweiler portrait* and the identification by Picasso of the image of a roof finial in the painting.

33 See André Salmon on the rational nature of African and Oceanic art "Histoire anecdotique du cubisme," in *La Jeune Painture Francaise*, 1912, (Paris, Société de trent, Albert Messein) 43.

34 See Daix and Rousselet, 1997 (as in no. 17) 259, for the *Boston Woman*.

35 See Daix and Rousselet, 1997 (as in no. 17) 269 for *Landscape by Céret*.

36 See Rubin (as in no. 29) 68, for *Ma Jolie*. See Richet (as in no. 19) for nos. 277, 278 and 296 three studies for *Ma Jolie*. 278 includes likenesses of Eva and Picasso.

37 See Daix and Rousselet, 1977 (as in no. 17) 178 for information on *Still Life with Chair Caning*. See Christine Poggi, *In Defiance of Painting: Cubism, Futurism and the Invention of Collage* (Yale University Press, 1992) for a discussion of the "untransformed" materials in *Still-Life with Chair Caning*.

38 See Daix and Rousselet, 1997 (as in no.17) 123 for *Man with a Guitar*, 357 and for the summer 1912 photograph that shows its Vaariation Seven state.

39 See Robert Rosenblum, "Picasso and the Typography of Cubism," in Roland Penrose and John Golding ed. *Picasso in Retrospect*, 1973, 49. In this essay Rosenblum introduces the reading of Picasso's newspaper clippings.

40 See Anne Umland "The Process of Imagining a Guitar," in Anne Umland ed. *Picasso's Guitars: 1912-14*, exh. catalogue, 2011, Museum of Modern Art, New York City, 17, on Picasso's *Guitar*. See William Rubin ed. *Primitivism in Twentieth Century Art*, exh, catalogue, 1984, 20, for influence of the *Grebo Mask* on *Guitar*.

The cardboard version is based on Variation Eight while the metal reproduction, 1914, is based on frontal perspective.

41 See Rubin (as in no.28) 92, on *Pipe, Glass and Bottle of Rum*, March 1914. Picasso dated this work perhaps to mark the change in perspective.

42 See Rubin (as in no,28) 98, on *Harlequin* and where it states that Alfred Barr identified *Harlequin* as the work Picasso refers to in his letter to Gertrude Stein. This letter is in the Archives Collection of American Literature, Beineche Rare Book Library, Yale University.

43 See Kirk Varnedoe, "Picasso's Self Portraits" in William Rubin ed. *Picasso and Portraiture*, exh. cat. Museum of Modern Art, New York City, 1996, 145, and note 43 for the Harlequin held Picasso portrait.

44 I seem to be alone in identifying the image of Eva in this area. See John Richardson *A Life of Picasso*, Vol. II, 1007-1917, 1996, 375 and 386 on the death of Eva Gouel.

45 See Daix and Rousselet, 1997 (as in no.17) 293 on *Nude Woman*, "Jaime Eva."

46 See Daix and Rousselet, 1997 (as in no.17) 295 on *Still Life (au Bon Marché)*. See Robert Rosenblum (as in no. 40) for a lascivious reading of this work. Rosalind Krause in Zelevansky (as in no.1) 81 takes exception with this reading as do I. See Richardson (as in no.4) 278 on Frika.

47 See William Rubin "Reflections on Picasso and Portraiture" in Rubin (as in no.43) 68, for a different view of *Still Life with a Pedestal Table*. See Bernhard Geisen, *Picasso: Painter Graver*, 1955, 219 for Picasso's 1905 dry point, *Salome*. John Richardson describes the Marie Walter image hidden in this still life and makes reference to Picasso's quixotic penchant for anthropomorphic still life. See Richardson (as in no, 4, Vol. III, 440 and 149-150).

48 See Francoise Gilot, *Life with Picasso*, 1946, 219 for the painting of *The Kitchen* version II. It would seem that Francoise did not know of the painting's hidden portraits.

49 See Rubin (as in no. 28) 112 and 114 on *Three Musicians* and *Three Women at the Spring*.

50 See Rubin (as in no, 28) 138, on *Girl Before a Mirror*.

Cézanne Notes

51 See John Rewald, *The Paintings of Paul Cézanne: A Catalogue Raisonné*, (New York: Harry N. Abrams Inc. 1996). Numbers in this text prefixed by R refer to entries in the Rewald catalogue. Dates used are those of the Rewald catalogue unless otherwise noted. The Emile Bernard photograph is in the Vollard archives, Musée d'Orsay, Paris and reproduced p.511, Rewald Catalogue.

52 For Cézanne criticism see Joseph J. Rishel and Francoise Cachin "A Century of Cézanne Criticism" in *Cézanne*, exh. cat. Francoise Cachin, Isabelle Cahn, Walter Feilchenfelt, Henri Layrette and Joseph Rishel (Harry N Abrams Inc., New York, in association with the Philadelphia Museum of Art, 1996) 23-75 and George Heard Hamilton "Cézanne and His Critics" in *Cézanne: The late Work*, exh. cat. William Rubin ed. (The Museum of Modern Art, New York, 1977) 139-147. Cézanne criticism based on Cézanne's supposed "flawed" perspective evolved from being largely negative to largely positive based on various interpretations of the same "flaws". It is hard to find value in criticism or explanations based on works not correctly seen.

53 After 1895 Vollard came to control most of Cézanne's unsold works. See Robert Jensen "Vollard and Cézanne" in *Cézanne to Picasso: Ambroise Vollard, Patron of the Avant Garde* exh. cat. ed. Rebecca Robinow (Metropolitan Museum of Art, New York, 2006) 28. Jensen questions Vollard's business practices and treatment of artists as has John Rewald. See John Rewald *Cézanne and America, Dealers, Collectors, Artists and Critics 1891-1921* (New York Graphic Society), 47. More specifically there is the case of the Cézanne lithograph, *Large Bathers*, published by Vollard. See Douglas Druick, "Cézanne Lithographs" in *Cézanne: The Late Work*, exh. cat. ed. William Rubin (The Museum of Modern Art, New York, 1977) 119-37. For the color lithograph, *Large Bathers*, see Lionello Venturi, *Cézanne, Son Art--Son Oeuvre*. (Editions Paul Rosenberg, Paris, 1936). Venturi 1157. This print is based on frontal perspective rather than Cézanne perspective making it a copy of rather than a Cézanne. *Small Bathers*, Venturi 1156 and *Portrait of Cézanne*, Venturi 1158 are based on Cézanne perspective. Druick describes Vollard's practice of having his printer Auguste Clot "translate" the work of various artists to produce prints that Druick calls facsimiles a practice that was as an issue at the time.

54 See appendix for list of Cézanne paintings I see on the basis of perspective as altered, or misattributed.

55 Monet for most of his career uses Attic perspective with a fixed ego.

56 The under appreciated Achille Emperaire uses Hellenic perspective.

57 Pissaro used fixed ego frontal perspective.

58 Degas used Hellenic perspective while Renoir uses fixed ego Hellenic perspective.

59 Dr. Paul Gachet who opened his studio in Auvers to Cézanne in the seventies was an amateur painter as was his son. On the Gachets see Wlater Feilchenfelt, "On Authenticity" in Rewald, (as in no. 51) vol. I. 13.

60 For Egisto Fabbri see Rewald, *The Paintings of Paul Cézanne*, (as in no. 51) vol I, 230.
 see R448, *Bathers*, as a copy of a work by Cézanne that is reproduced on page 303.

61 *Three Bathers*, R360, is based on a perspective Matisse introduced in 1907, a wide view fixed ego Hellenic perspective with forms then seen related to the not aligned ego. Unlike Cézanne Matisse leaves forms related to a not aligned ego. *Three Bathers* appears intact in a Vollard photograph of the Cézanne room at the 1904 Salon d'Automne to which it had been lent by Matisse. This photograph is reproduced in Rishel, (as in no.51)

564-65. Matisse's changing of *Three Bathers* and other Cézannes in his possession demonstrates his lack in understanding Cézanne.

62 The perspective used to repaint R365 and R395 is the Seventh Variation of Picasso's Perspective.

63 For these photographs see Rishel, (as in no.1) 564-65.

64 See note 55.

65 See *Cézanne's Card Players*, exh. cat. ed. Nancy Iverson and Barnabay Wright, (The Courtald Gallery in Association with Paul Holbrt Publishing, London, 2011) for Cézanne's card player paintings.

66 I believe Matisse repainted this work on the basis of his ownership and the perspective he used. See note 61.

67 Rewald lists R718 as possibly passing through Vollard's hands. Its altered state makes me believe that it did.

68 Degas it seems had extensive dealings with Vollard. The perspective used in repainting these still lives is wide view Hellenic perspective. R675 is not identified in the Rewald catalogue as coming from the Vollard Gallery. It appears intact in the photographs of the Cézanne room at the 1904 Salon d'Autome Its original owner is listed as Eugene Blot. See note 58. I believe that four other Cézannes based on Hellenic perspective to be misattributed. These are R850, *Man with Crossed Arms*, Private Collection, which appears based on the intact R851, *Man with Crossed Arms*, The Guggenheim Museum, New York, ca.1899, the so called *Clock Maker*; R936, *Still Life with White Pitcher*, National Museum of Wales, Cardiff, which appears to be loosely based on R848, *Still Life*, Private Collection; R944, *Woman in Blue, 1902-04, Hermitage Museum*, which appears to be loosely based on R945, *Woman with A Book*, 1902-4, The Phillips Collection, Washington, DC and R948, *The Sailor*, 1902-06, Private Collection, which appears to be a copy of R949, *The Sailor*, The National Gallery of Art, Washington DC. I suspect all four of theses works to be by Edgar Degas because of the wide view Hellenic perspective used and passages that strongly suggest the style of Degas. All four were were sold by Vollard as Cézannes. Did he commission then?

69 See Ambroise Vollard, *Paul Cézanne*,(Paris, 1914) 91-107.

70 Bibémus was a source of the yellow stone with which 17th century Aix was built. As far as I can tell Cézanne painted no views of his beautiful home town. It seems to me that Cézanne was more interested in meaning as generated by form than by the subject.

71 See note 61 above on Matisse's perspectives.

72 Both the Barnes and the London *Large Bathers* show signs of at one time being larger in size. With the Barnes painting there are strips along the right side and at the bottom that appear discontinuous with adjacent surfaces. With the London painting these strips exist at the top and bottom and along the right side. I see these strips preserving the original Cézanne perspective which was not changed when the these works were repainted I believe at the behest of Vollard because they were not visible at that time. The changes in size may have occurred after the paintings were moved from Cézanne's Paris studio to his new studio outside Aix at Les Lauves. See Richard Shiff's review of the Rewald catalogue in *The Art Bulletin*, June 1996, Vol. LXXX, No. 2, 384. Shiff describes these discontinuous strips and suggest that these paintings could have been altered by "an honest admirer or a dishonest entrepreneur." Shiff also raises the possibility that Vollard had work done on the Barnes bathers with which I heartily agree. John Rewald, *Rewald Catalogue*, 510, also discusses changes to the Barnes and London paintings. Rewald writes that the Barnes *Bathers* was changed by Cézanne after the 1904 photograph was taken. On the changes by Cézanne to the Barnes *Large Bathers* see also T. J. Clark, *Farewell to an Idea, Episodes from a History of Modernism*, 1999, Yale University Press, New Haven, CT, 147. I feel certain that the changes made by Cézanne are not the frontal perspective changes that make the Barnes *Large Bathers* no longer a true Cézanne.

73 See Fred Leeman "Painting 'after' Cézanne" in *Cézanne and the Dawn of Modern Art*, exh. cat. ed. Felix A Bauman, Water Feilchenfeldt, Hubertus Gasser (Hatje Cantz Verlag, Essen, 2004) 170-180. Leeman calls the next generation's response to Cézanne "creative misunderstanding". On Cézanne's influence see also *Cézanne and Beyond*, exh. cat. Joseph J. Rishel and Katherine Sachs (Philadelphia Museum of Art in Association with Yale University Press, New Haven and London, 2009). The two artists who's perspectives come closest to Cézanne's are Henri Matisse and Pablo Picasso. A perspective used by Matisse beginning in 1904-05 is based on a wide view followed by forms rleated to the not aligned ego. This differs from Cézanne perspective in which forms are finally presentsed in relation to the large static aligned ego.